THE BOOK OF BLANK PAGES

Will Dreamly Arts
PUBLISHING

For information contact:
Will Dreamly Arts Publishing
info@WillDreamlyArts.com
www.WillDreamlyArts.com

Designed by Will Dreamly Arts Publishing
Back cover portrait by River Jordan
www.riverjordanphoto.com

The Book of Blank Pages is also available in EBook formats.

Library of Congress Cataloging-in-Publication Data has been applied for.

ISBN: 978-0-9976234-8-2

1 3 5 7 9 10 8 6 4 2

Will Dreamly Arts
PUBLISHING

Dear Reader:

This book is a White Painting.

Painters have been known to spend hundreds of hours covering a canvas with white paint. These "White Paintings" have sold for millions of dollars.

The Hubble Space Telescope pointed at a patch of nothing in the sky for 100 hours. It stared into emptiness discovering 3,000 whirling galaxies.

Like a mirror, a void is filled by whoever stands in front of it and looks in.

If you stare at a blank page long enough, you will find it was never blank to begin with.

Dedicated to:

Table of Contents:

[This page is Antarctica.]

[This page is the top of Everest.]

[This page is one of the loneliest places in the world.]

[This page is the exact distance from me to you.]

[This page is a bandage before the roses and the chrysanthemums.]

[This page is a white blood cell.]

[This page is the pill I take when the world is ugly.]

[This page is the poison I spit up when the world is beautiful.]

[This page is Sisyphus's stone.]

[This page is Samson's donkey jaw bone.]

[This page is the surface of the moon. If I push hard enough I'll never come back.]

[This page is a straitjacket.]

[This page is a crack in the ceiling of the Sistine Chapel that keeps increasing the distance between God and Man.]

[This page is the body of the Eucharist.]

[This page is a crack in the floor of the Colosseum caked with ancient blood.]

[This page is the meat of Eden's apple.]

[This page is the weight of 180 human tears.]

[This page, when turned, sounds like rain.]

[This page is her tan line.]

[This page is a rough sea.]

[This page is a dismantled daisy. He loves you. She loves you not. Wedding cake. Rice clinging to a bridal veil. A snowflake in a blizzard. Winter lost in winter.]

[This page is the first bite mark of spring.]

[This page is an egg.]

[This page is a cartoon fight cloud where random body parts make an appearance.]

[This page is exposed leg bone. The motel towel dad used to stop the gushing. The place the brain goes when the tongue can't language. The ambulance roof. The hospital walls. Knife glare. Scar tissue.]

[This page is smoke I push through to find the source.]

[This page is a highway line. The last gas station for 50 miles. On-coming traffic.]

[This page is a ballet slipper. Delicate house of ache and deformity.]

[This page is human gossamer, how we balloon and anchor in the electric wind.]

[This page is dandruff and dream dirt. Torn finger nail. Dead skin flake. Human proof. Evidence.]

[This page is elephant tusk.]

[This page is the bathroom sink the night a bottle of suntan lotion saved my life. The girl on the label looked so happy. It made me think… Maybe… If… If I could just… Maybe… Get… To the next sun. Then, maybe… Maybe…]

[This page is the last light of a dying star millions of light-years away. By the time it reaches us we will be light too.]

[This page is blank on purpose.]

Acknowledgements:

My forever gratitude to *Will Dreamly Arts Publishing* and the following people without whom these pages (and the pages of my life) would be blank:

My parents: Paul and Sandra Shafer.

My friends, family, mentors, and rubrics: JoLynn Shafer. Stan Koep. Michael Koep. Andreas John. Adriana Ambriz. Paul Vicknair. Acasia Stratt Vicknair. Kathleen Crowley Stratt. Ronnie Gunter. Scott Rich. Cheryl Cross.

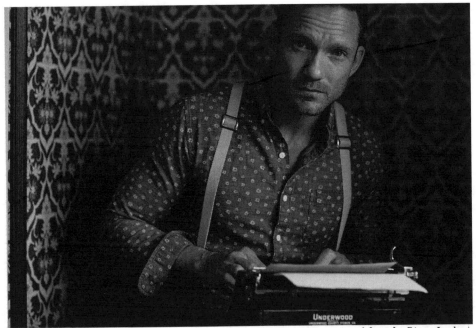
(photo by River Jordan)

A former combat medic, C.P. Shafer's poems and short stories have appeared online and in various literary journals. He is the author of the poetry collection *My Father's Hand Is a Mountain Range*. He lives and works in California.

w w w . c p s h a f e r . c o m